WOMEN

WOMEN

An Illustrated Treasury

Compiled by Michelle Lovric

an imprint of
RUNNING PRESS
Philadelphia, Pennsylvania

*I*NTRODUCTION

WOMEN, IN ALL THEIR MANY ROLES—MOTHER, CHILD, LOVER, FRIEND, PHILOSOPHER, WORKER, ARTIST, COMEDIAN, OBSERVER—HAVE PROVIDED RICH COMMENTARY ON THE WAYS OF THE WORLD, THEIR WORDS INFORMED AND ENHANCED BY THEIR FEMININITY. THEY SPEAK FROM VARIED PROFESSIONS, ERAS, AND BACKGROUNDS, OFFERING PASSIONATE IDEALISM, EXQUISITE HUMOR, ELEGANT IRONY, AND SIMPLE JOY.

IN THIS BOOK, AS IN LIFE, WOMEN CHALLENGE, COMFORT, AMUSE, INSPIRE—AND MOST OF ALL, SHARE. TO THEIR WILLINGNESS AND SENSITIVITY TO UNDERSTAND THE NEEDS AND DESIRES OF THOSE WHO SURROUND THEM, WOMEN ADD THEIR GENEROSITY, AND HELP THOSE THEY LOVE TO FULFILL THEMSELVES AND SHINE.

MANY ARTISTS, BOTH MEN AND WOMEN, HAVE FOUND WOMEN TO BE FASCINATING AND AESTHETIC SUBJECTS. THIS BOOK WEAVES TOGETHER WORDS AND IMAGES OF WOMEN IN A CELEBRATION OF THE ART OF BEING A WOMAN.

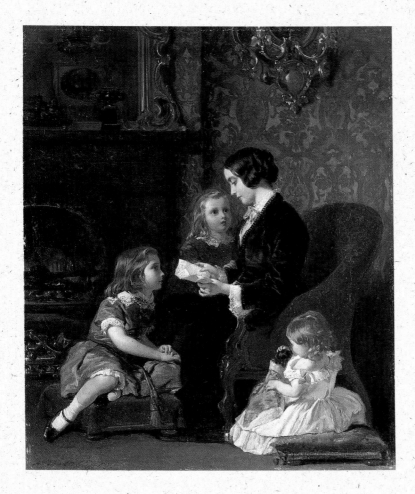

Women

are the

real

architects

of society.

Harriet Beecher Stowe (1811–1896)
American writer

A WOMAN IS THE FULL CIRCLE.
WITHIN HER IS THE POWER TO CREATE,
NURTURE, AND TRANSFORM.

DIANE MARIECHILD
20TH-CENTURY AMERICAN PSYCHOTHERAPIST

Above the titles of wife and mother, which, although dear, are transitory and accidental, there is the title human being, which precedes and outranks every other.

Mary Ashton Livermore (c. 1820–1905)
American writer and social reformer

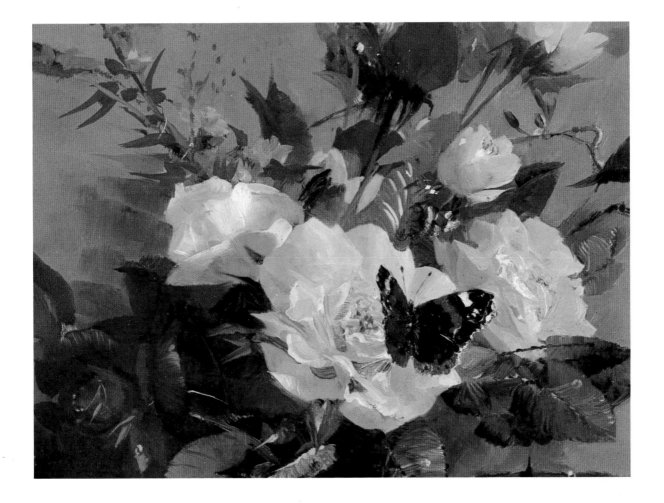

WHO KNOWS WHAT WOMEN CAN BE WHEN THEY ARE FINALLY FREE TO BECOME THEMSELVES?

BETTY FRIEDAN, B. 1921
AMERICAN FEMINIST AND WRITER

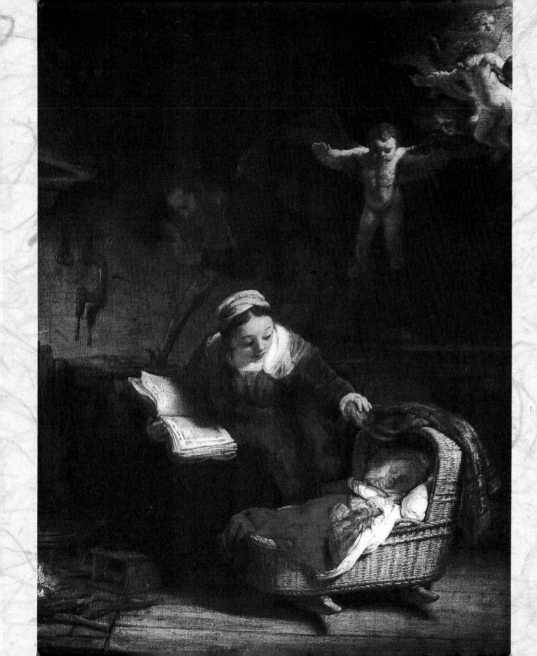

We
are
the
hero
of our
own
story.

Mary McCarthy, b. 1912
American writer

Since when was genius found respectable?

ELIZABETH BARRETT BROWNING
(1806–1861)
ENGLISH POET

A LEARNED WOMAN IS THOUGHT TO BE A COMET, THAT BODES

MISCHIEF WHENEVER IT APPEARS.

Bathshua Makin (1612–1674)
English scholar and writer

When a

woman

behaves

like a

man,

why

can't

she

behave

like a

nice

man?

DAME EDITH EVANS (1888–1976)
ENGLISH ACTRESS

TO BE SOMEBODY, A WOMAN DOES NOT HAVE TO BE MORE LIKE A

MAN, BUT HAS TO BE MORE OF A WOMAN.

Sally E. Shaywitz, b. 1942
American physician and writer

twelve

For women there are, undoubtedly, great difficulties in the path, but so much the more to overcome. First, no woman should say, 'I am but a woman!' But a woman! what more can you ask to be?

MARIA MITCHELL (1818–1889)
AMERICAN ASTRONOMER

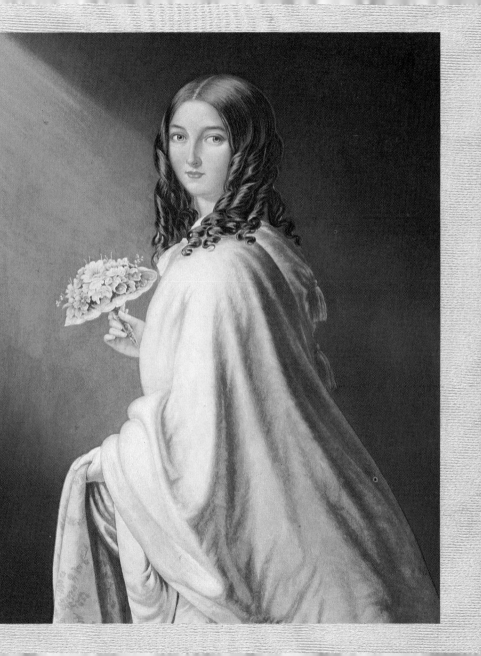

Whatever women do they must do twice as well as men to be thought half as good. Luckily, this is not difficult.

CHARLOTTE WHITTON (1896–1975)
CANADIAN WRITER

IT WOULD BE A THOUSAND PITIES IF WOMEN WROTE LIKE MEN, OR LIVED LIKE MEN, OR
LOOKED LIKE MEN, FOR IF TWO SEXES ARE QUITE INADEQUATE, CONSIDERING THE VASTNESS AND
VARIETY OF THE WORLD, HOW SHOULD WE MANAGE WITH ONE ONLY?

Virginia Woolf (1882–1941)
English writer

Minds

have no sex.

MARIE MEURDRAC
17TH-CENTURY FRENCH WRITER

THERE IS

MORE

DIFFERENCE

WITHIN THE

SEXES THAN

BETWEEN

THEM.

Dame Ivy Compton–Burnett (1892–1969)
English writer

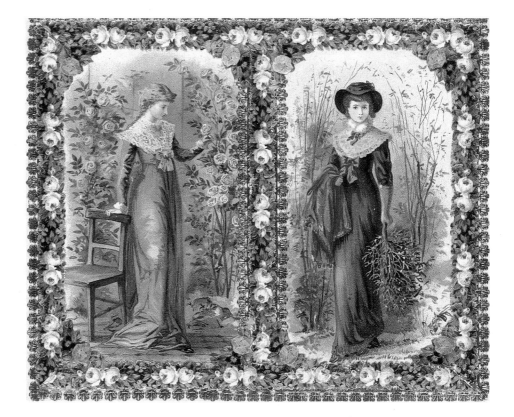

WE ARE NEITHER MALE NOR FEMALE. WE ARE A COMPOUND OF BOTH.

Katherine Mansfield (1888–1923)
New Zealand-born English writer

I give myself
sometimes
admirable
advice, but I
am incapable
of taking it.

MARY WORTLEY MONTAGU (1689–1762)
ENGLISH POET AND WRITER

It is wise to apply the oil of refined

politeness to the mechanism of friendship.

COLETTE (1873–1954)
FRENCH WRITER

A woman should, I think, love her husband better than anything on earth except her own soul, which I think a man should respect above everything on earth but his own soul; and there my dear is a very pretty puzzle for you, which a good many people have failed to solve.

FANNY KEMBLE (1809–1893)
ENGLISH ACTRESS

The giving of love is

an education in itself.

ELEANOR ROOSEVELT
(1884–1962)
AMERICAN WRITER
AND FIRST LADY

LOVE IS LIKE THE WILD ROSE-BRIAR;

FRIENDSHIP LIKE THE HOLLY-TREE.

THE HOLLY IS DARK WHEN THE ROSE-BRIAR BLOOMS,

BUT WHICH WILL BLOOM MORE CONSTANTLY?

Emily Jane Brontë (1818–1848)
English writer

BETTER TO BE IN LOVE THAN TO BE LOVED, BUT A STATE MORE DIFFICULT
TO ATTAIN. IF IN THE SEESAW OF AFFECTIONS BALANCE IS ATTAINED,
WHEN EACH LOVES THE OTHER EQUALLY YET STILL DESPERATELY, WHY
THEN THERE IS THE PRESENCE OF GOD, AND PARADISE: ONLY THEN WHAT
HAPPENS IS THAT WE START LONGING FOR THE SNAKE TO ARRIVE AND
CREATE A DIVERSION.

Fay Weldon, b. 1931
English writer

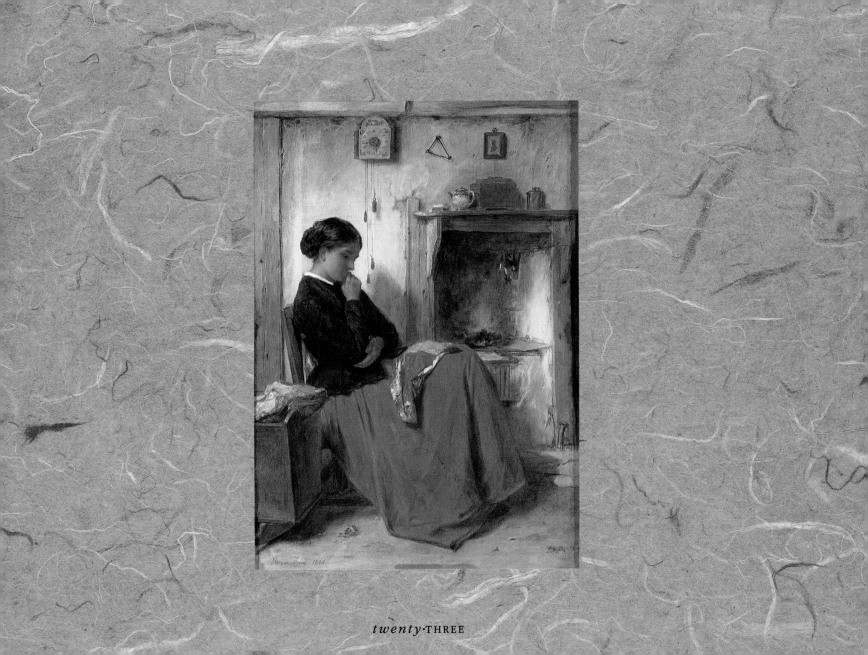

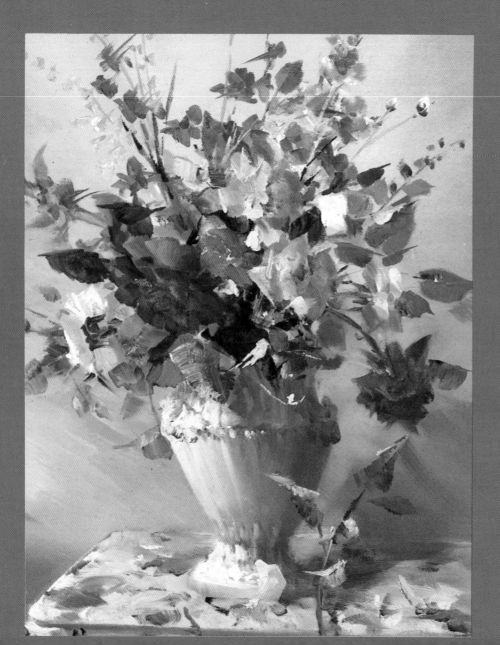

Life is a stream
On which we strew
Petal by petal the flower of our heart...

AMY LOWELL (1874–1925)
AMERICAN POET AND WRITER

WHAT I DO

AND WHAT I DREAM INCLUDE THEE, AS THE WINE

MUST TASTE OF ITS OWN GRAPES.

Elizabeth Barrett Browning (1806–1861)
English poet

Because I love

The iridescent shells upon the sand

Take forms as fine and intricate as thought.

KATHLEEN RAINE, B. 1908
ENGLISH POET

H

ᴇ SIMPLY SAID MY NAME.

Edna O'Brien, b. 1932
Irish writer

Wʜʏ ᴅɪᴅ ʏᴏᴜ ʟᴇᴛ ʏᴏᴜʀ ᴇʏᴇs sᴏ ʀᴇsᴛ ᴏɴ ᴍᴇ

Aɴᴅ ʜᴏʟᴅ ʏᴏᴜʀ ʙʀᴇᴀᴛʜ ʙᴇᴛᴡᴇᴇɴ?

Iɴ ᴀʟʟ ᴛʜᴇ ᴀɢᴇs ᴛʜɪs ᴄᴀɴ ɴᴇᴠᴇʀ ʙᴇ

As ɪғ ɪᴛ ʜᴀᴅ ɴᴏᴛ ʙᴇᴇɴ.

Mary Coleridge (1861–1907)
English poet

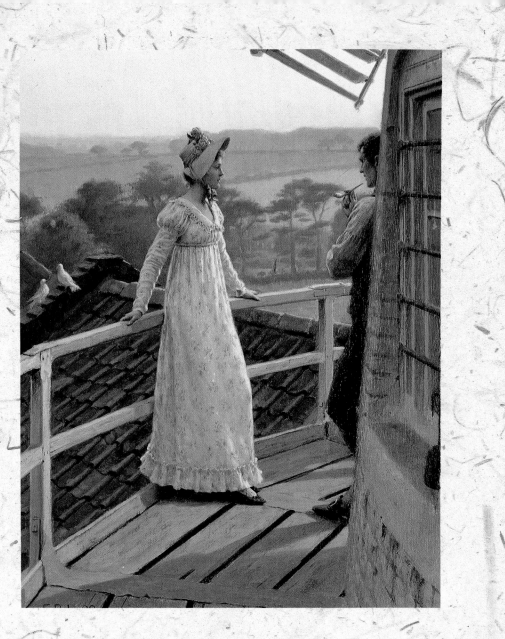

COME TO ME IN THE SILENCE OF THE NIGHT;

COME IN THE SPEAKING SILENCE OF A DREAM;

COME WITH SOFT ROUNDED CHEEKS AND EYES AS BRIGHT

AS SUNLIGHT ON A STREAM;

COME BACK IN TEARS,

O MEMORY, HOPE, LOVE OF FINISHED YEARS.

Christina Rossetti (1830–1874)
English poet

Memory is
history
recorded
in our
brain,
memory is
a painter,
it paints
pictures of
the past
and of
the day.

GRANDMA MOSES
[ANNA MARY ROBERTSON MOSES]
(1860–1961)
AMERICAN PAINTER

I smile to think that days remain

Perhaps to me in which, though bread be sweet

No more, and red wine warm my blood in vain,

I shall be glad remembering how the fleet,

Lithe poppies ran like torchmen with the wheat.

HELEN JACKSON (1830–1855)
AMERICAN WRITER

THE
GREATEST
THING
ABOUT
GETTING
OLDER IS
THAT YOU
DON'T LOSE
ALL THE
OTHER
AGES
YOU'VE
BEEN.

Madeline L'Engle, b. 1918
American writer

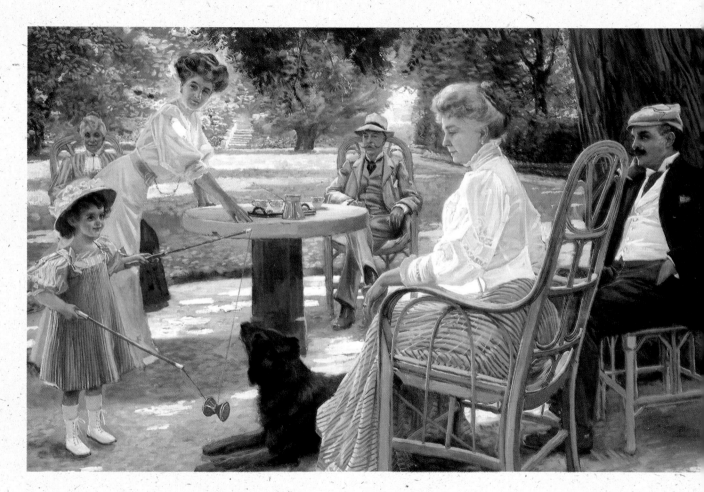

WE COULD
NEVER HAVE
LOVED THE
EARTH SO
WELL IF WE
HAD HAD NO
CHILDHOOD
IN IT.

George Eliot [Mary Ann Evans] (1819–1880)
English writer

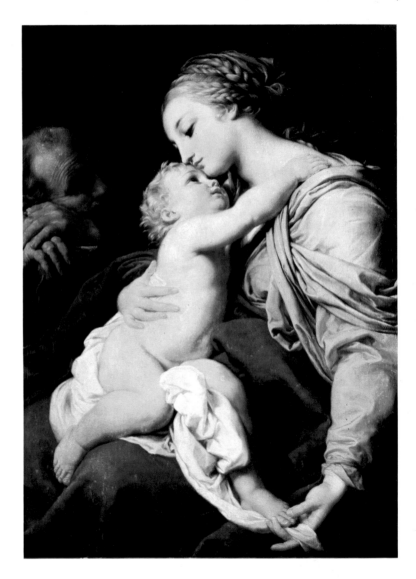

Some people, you know, are never children, or only briefly. Some have their childhoods much later in their lives. It is certainly not the exclusive privilege of the very young, but merely that time when one feels the greatest awe, terror, and confidence in the universe and in oneself.

ISAK DINESEN [KAREN BLIXEN] (1885–1962)
DANISH WRITER

Many people have said to me "What a pity you had such a big family to raise. Think of the novels and the short stories and the poems you never had time to write because of that." And I looked at my children and I said, "These are my poems. These are my short stories."

Olga Masters (1919–1986)
Australian writer

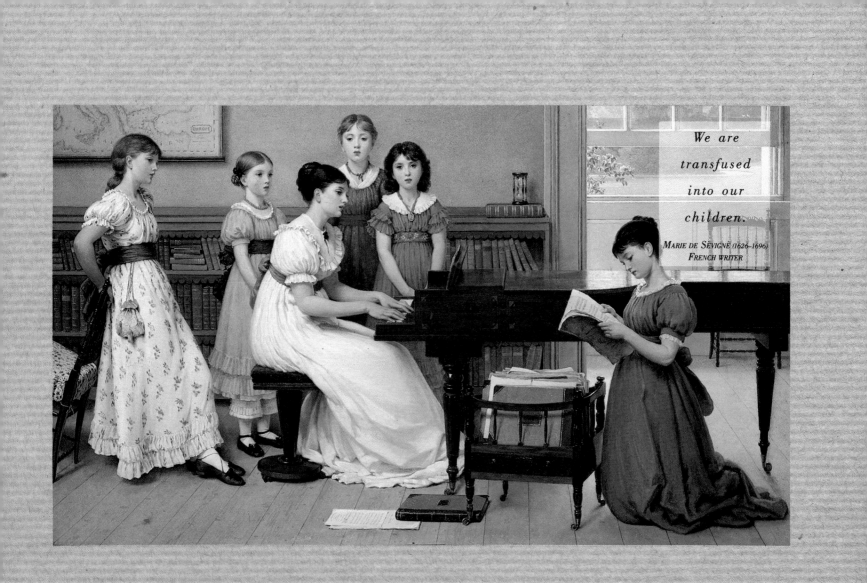

We are

transfused

into our

children.

MARIE DE SÉVIGNÉ (1626–1696)
FRENCH WRITER

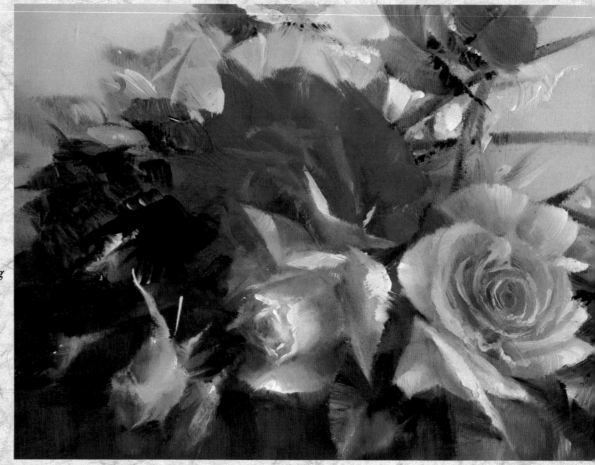

*Some people are still
unaware that reality
contains unparalleled
beauties. The fantastic
and unexpected, the
ever-changing and renewing
is nowhere so exemplified
as in real life itself.*

Berenice Abbott (1898–1991)
American photographer

LIFE COMES IN CLUSTERS, CLUSTERS OF SOLITUDE, THEN CLUSTERS WHEN THERE IS HARDLY TIME TO BREATHE.

May Sarton, b. 1912
Belgian-American writer

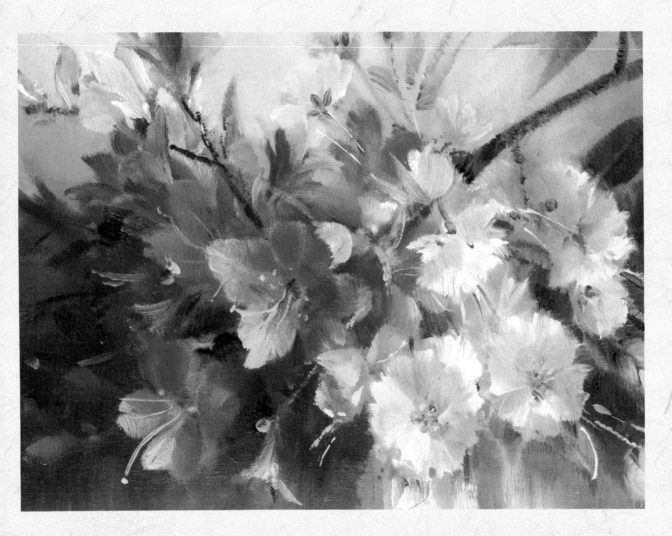

*Life's under
no obligation
to give us
what we
expect.*

MARGARET MITCHELL (1900–1949)
AMERICAN WRITER

I AM NOT AFRAID OF STORMS

FOR I AM LEARNING HOW

TO SAIL MY SHIP.

Louisa May Alcott (1832–1888)
American writer

 ne never notices what has been done; one can only see what remains to be done.

MARIE CURIE (1867–1934)
POLISH CHEMIST

ONE IS HAPPY AS A RESULT OF

ONE'S OWN EFFORTS, ONCE ONE

KNOWS THE NECESSARY

INGREDIENTS OF HAPPINESS—

SIMPLE TASTES, A CERTAIN DEGREE

OF COURAGE, SELF DENIAL TO A

POINT, LOVE OF WORK, AND, ABOVE

ALL, A CLEAR CONSCIENCE.

HAPPINESS IS NO VAGUE DREAM,

OF THAT I NOW FEEL CERTAIN.

George Sand [Amandine A. L. Dupin] (1804–1876)
French writer

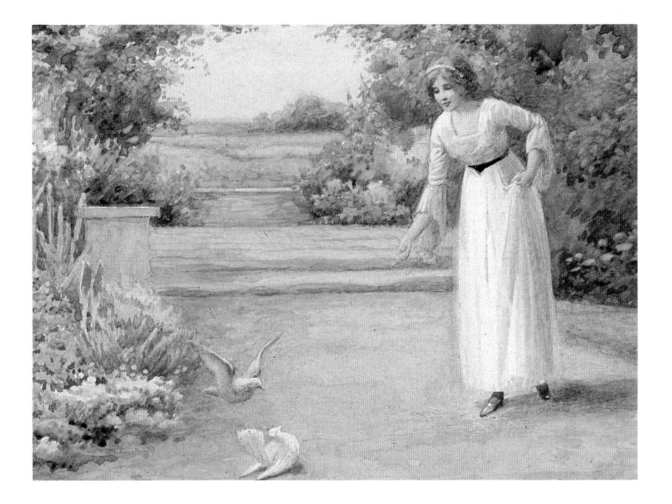

THE FUTURE IS MADE OF THE SAME STUFF AS THE PRESENT.

In what way are you different?. . . I tell you, there are a great line of women stretching out behind you into the past, and you have to seek them out and find them in yourself and be conscious of them.

I HAVE RECEIVED
TRUE PROSPERITY
FROM THE GOLDEN
MUSES, AND WHEN
I DIE SHALL NOT
BE FORGOTTEN.

SAPPHO (C. 612–580 B.C.)
GREEK POET

When a woman tells the truth she is creating the possibility for more truth around her.

ADRIENNE RICH, B. 1929
AMERICAN POET AND WRITER

THE WORLD CANNOT

DO WITHOUT WOMEN

THE FUTURE LIES WITH US.

*Joan Collins, b. 1933
British actress*

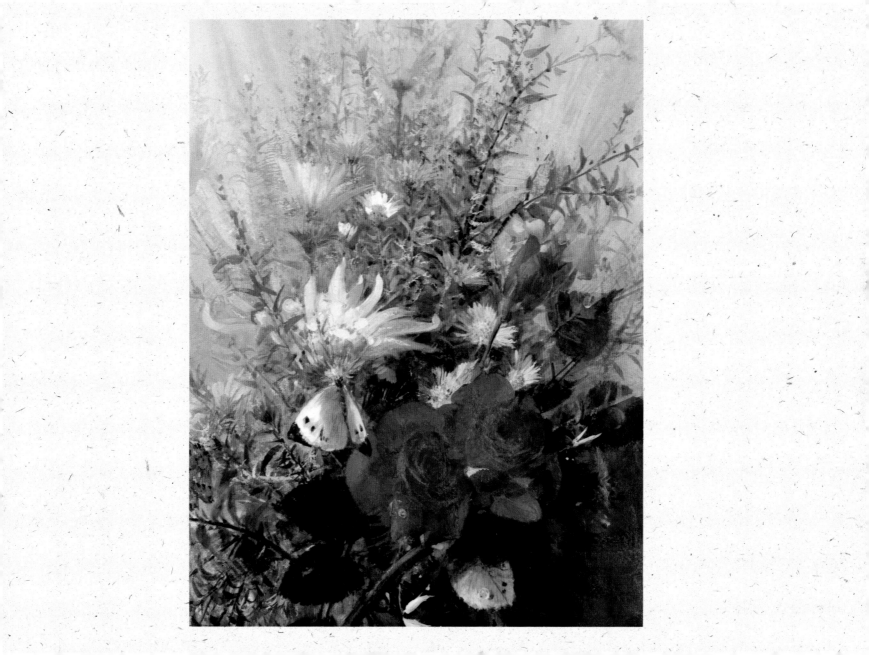

ILLUSTRATION ACKNOWLEDGMENTS

COVER: *The Arbour*, Sir Alfred Munnings
(Sir Alfred Munnings Art Museum, Dedham, Essex)

p. 3: *A Pretty Portrait*, George L. Seymour
(Fine Art Photographic Library Limited)

p. 7: *A Letter from Papa*, Francis Goodall
(Tunbridge Wells Museum and Art Gallery)

p. 9: *September Garden*, Vernon Ward

p. 10: *The Holy Family*, Rembrandt Harmensz van Rijn

p. 13: *The Bridesmaid*, from an original Baxter print

p. 14: *Tennis at Vechiville*, Frederick Arthur Bridgman
(Fine Art Photographic Library Limited)

p. 17: *Two Women in Floral Settings*, unknown artist